Super Simple Sumi-e

Easy Asian Brush Painting for All Ages

Yvonne Palka

little bigfoot

an imprint of sasquatch books

seattle, wa

To all the wonderful teachers who have taught me to paint from my heart . . . and to the spirit of creativity in the hearts of all.

—Y. P.

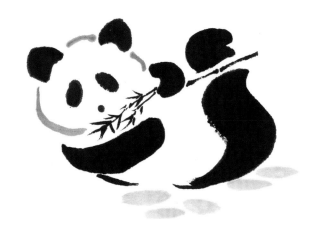

Manufactured in China by C&C Offset Printing Co. Ltd. Shenzhen, Guangdong Province, in September 2021

LITTLE BIGFOOT with colophon is a registered trademark of Penguin Random House LLC

Originally printed as a hardcover by Sasquatch Books in 2018

25 24 23 22 21 9 8 7 6 5 4 3 2 1

Editor: Christy Cox
Production editor: Bridget Sweet
Photographs: Hilary McMullen
Design: Tony Ong
Original design: Yachun Peng

Library of Congress Cataloging-in-Publication Data is available

ISBN: 978-1-63217-204-4 (hardcover)
ISBN: 978-1-63217-446-8 (paperback)

Sasquatch Books
1904 Third Avenue, Suite 710
Seattle, WA 98101
SasquatchBooks.com

MIX
Paper from responsible sources
FSC® C008047
www.fsc.org

Contents

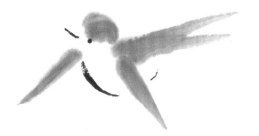

Welcome

to the lively world of *sumi-e* (pronounced soo-me-ay). *Sumi* means "ink" in Japanese and *e* means "painting," so sumi-e simply means "ink painting." There's wonderful freedom in painting with brush and ink, and capturing the essence of a flower or a panda with just a few lines. This book shows you how to paint lots of different animals and combine them into paintings. There is a saying in Japan and China: "The brush dances and the ink sings." May you learn to do this as you explore the lessons in this book.

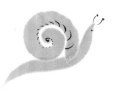

LOOK AT ALL THESE DIFFERENT STROKES!

These strokes are all you need to create animals and landscapes. Soon you will see how a side stroke becomes a bamboo stalk and a press stroke becomes a flower. Guess what you can paint with the freestyle line? For detailed instructions on how to make these strokes see pages 35–36.

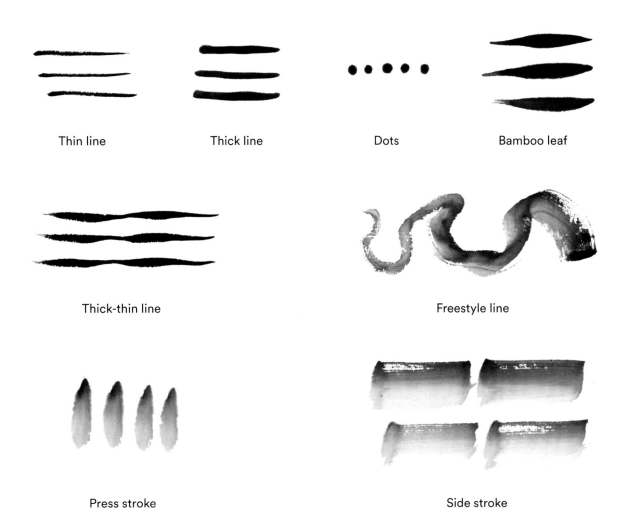

Thin line

Thick line

Dots

Bamboo leaf

Thick-thin line

Freestyle line

Press stroke

Side stroke

TRY YOUR HAND AT THE PRESS STROKE

When you load the brush with gray and black, you can make paintings with lots of depth!
The key in *Super Simple Sumi-e* is using a few different strokes in a variety of ways.

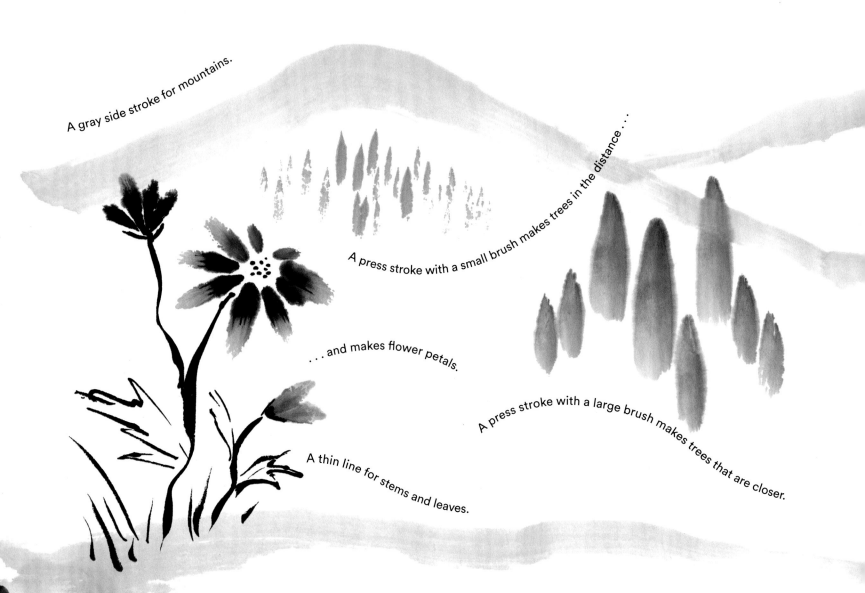

A gray side stroke for mountains.

A press stroke with a small brush makes trees in the distance . . .

. . . and makes flower petals.

A press stroke with a large brush makes trees that are closer.

A thin line for stems and leaves.

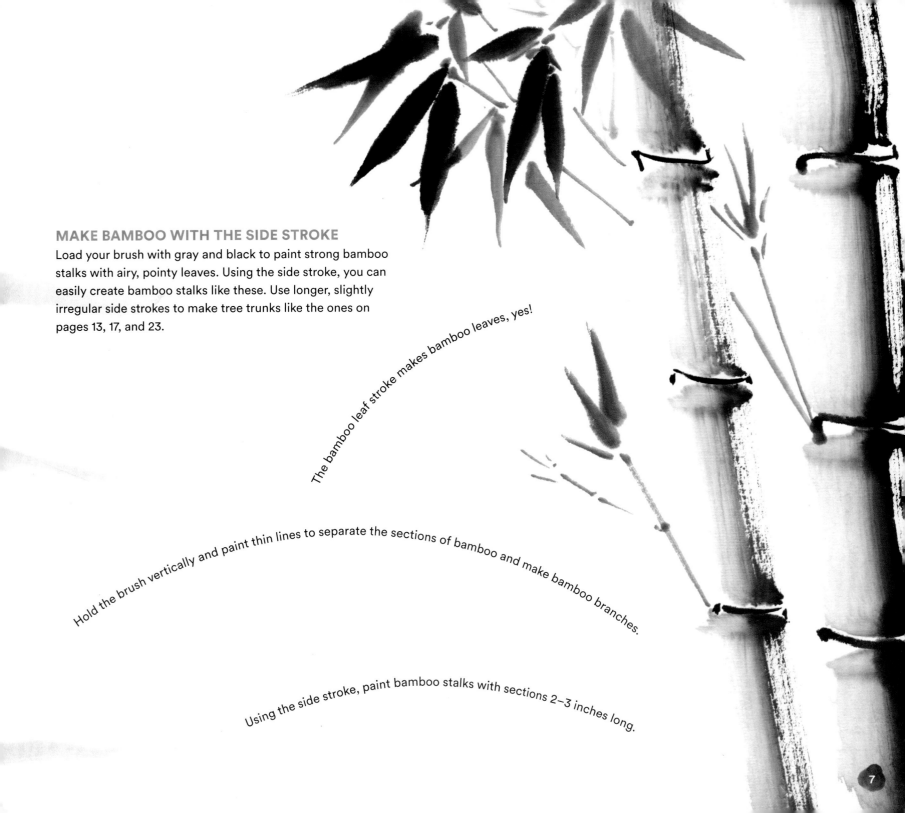

MAKE BAMBOO WITH THE SIDE STROKE

Load your brush with gray and black to paint strong bamboo stalks with airy, pointy leaves. Using the side stroke, you can easily create bamboo stalks like these. Use longer, slightly irregular side strokes to make tree trunks like the ones on pages 13, 17, and 23.

The bamboo leaf stroke makes bamboo leaves, yes!

Hold the brush vertically and paint thin lines to separate the sections of bamboo and make bamboo branches.

Using the side stroke, paint bamboo stalks with sections 2–3 inches long.

The Gray Guys

You can make a snail, mouse, or rabbit by using the "gray blob" technique. Then add details with a fine brush or black marker pen.

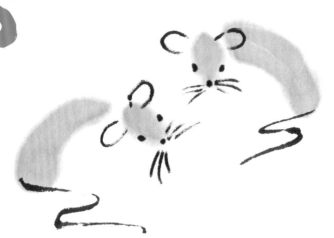

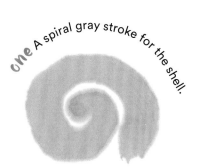

one A spiral gray stroke for the shell.

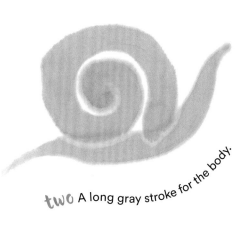

two A long gray stroke for the body.

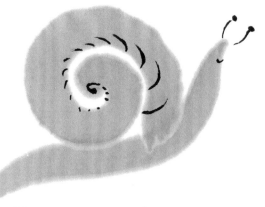

three Wait for the gray to dry! Then add eyestalks and marks on the shell.

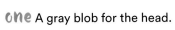

one A gray blob for the head.

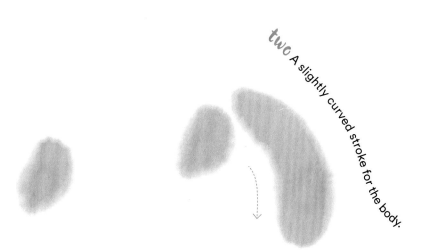

two A slightly curved stroke for the body.

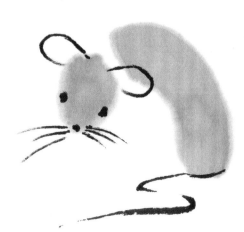

three Eyes, ears, whiskers, and tail!

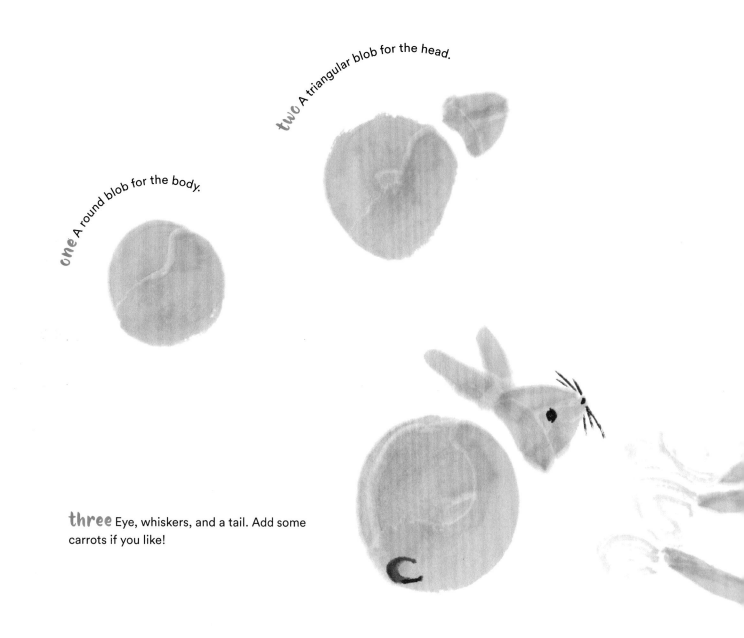

one A round blob for the body.

two A triangular blob for the head.

three Eye, whiskers, and a tail. Add some carrots if you like!

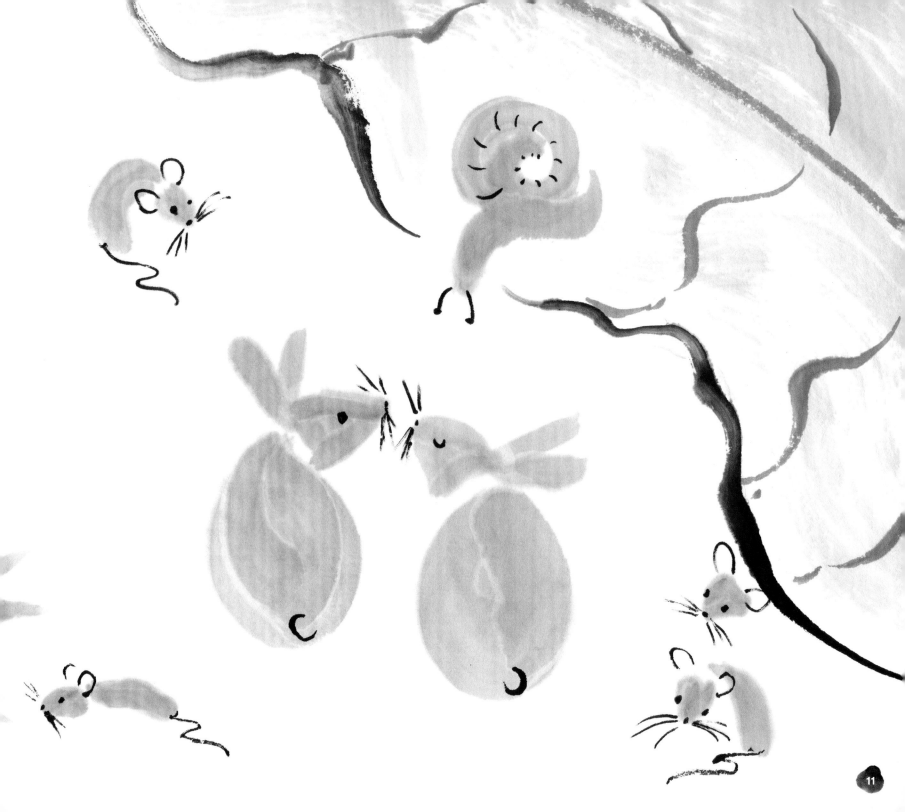

Flights of Fancy

With a few simple strokes, you can make chicks, swallows, and fancy birds.

one A curved side stroke for the head.

two Add two curved strokes for the body.

three A dot for the eye and a thin line for the bill.

four A perch for the bird and some claws for its feet.

five Use press strokes to make some tail feathers.

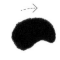

one A curved stroke for the head.

two Make two bamboo leaf strokes for wings.

three Add two long, crossed bamboo leaf strokes for the body and tail.

four Paint the eye and lines for the bill and body.

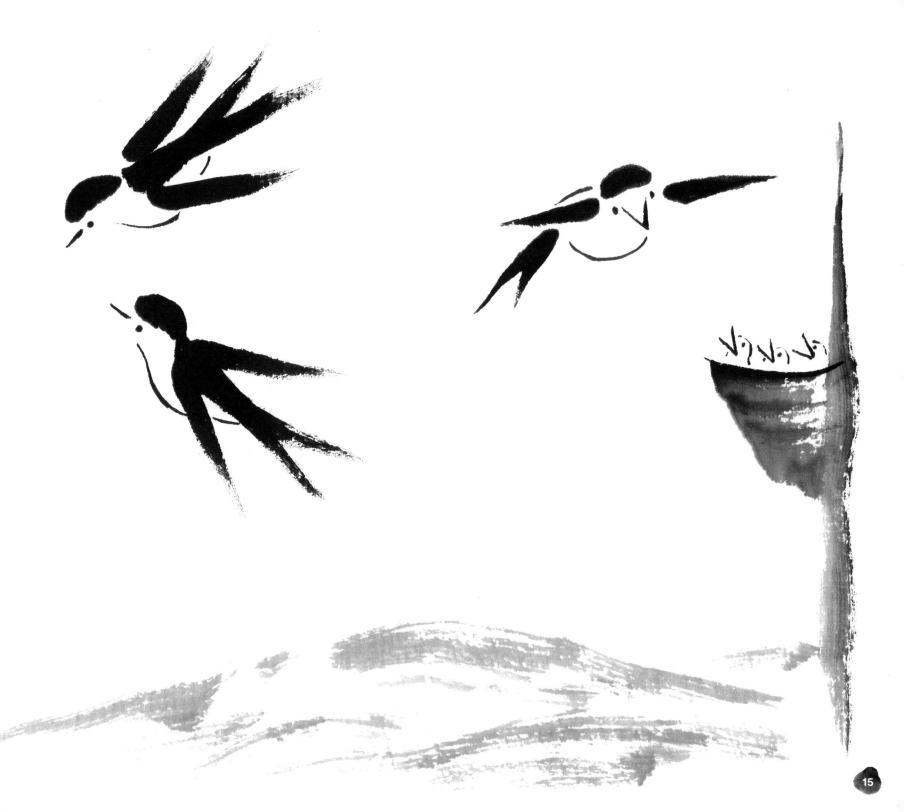

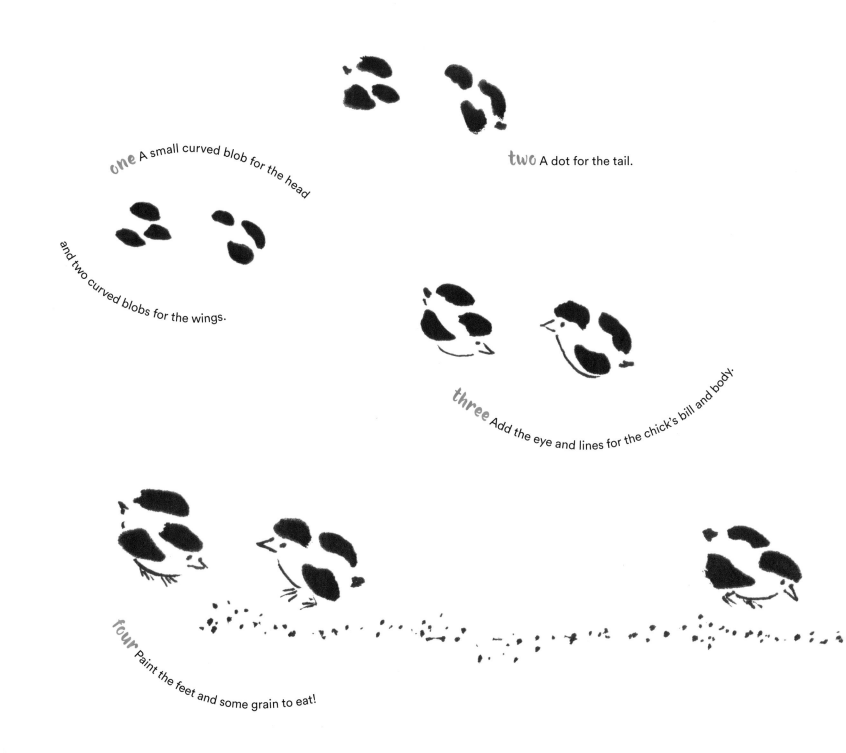

one A small curved blob for the head

two A dot for the tail.

and two curved blobs for the wings.

three Add the eye and lines for the chick's bill and body.

four Paint the feet and some grain to eat!

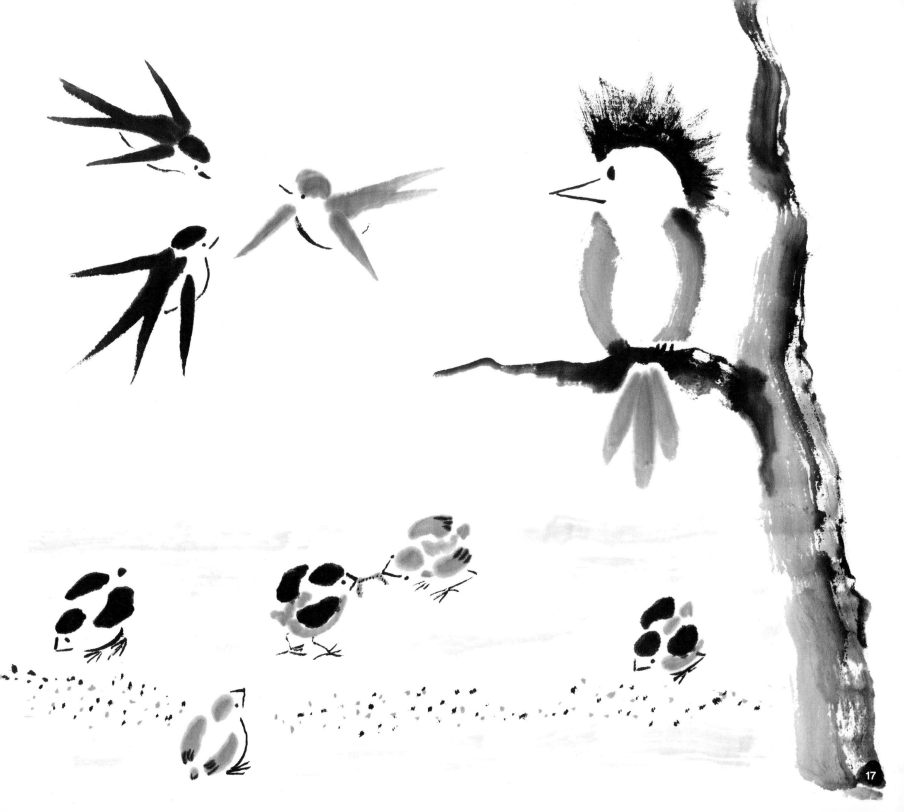

Panda-monium

Blobs, patches, strokes, and lines! That's all you need to paint a panda.

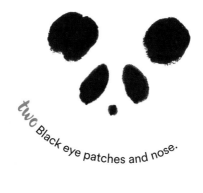

two Black eye patches and nose.

one Two black blobs for the ears.

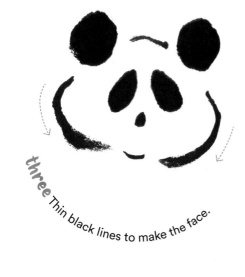

three Thin black lines to make the face.

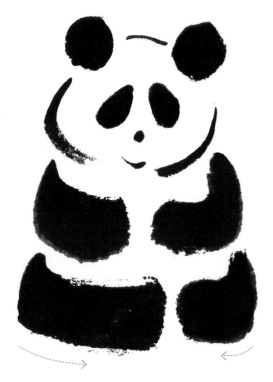

four Thicker black side strokes for the front and back legs.

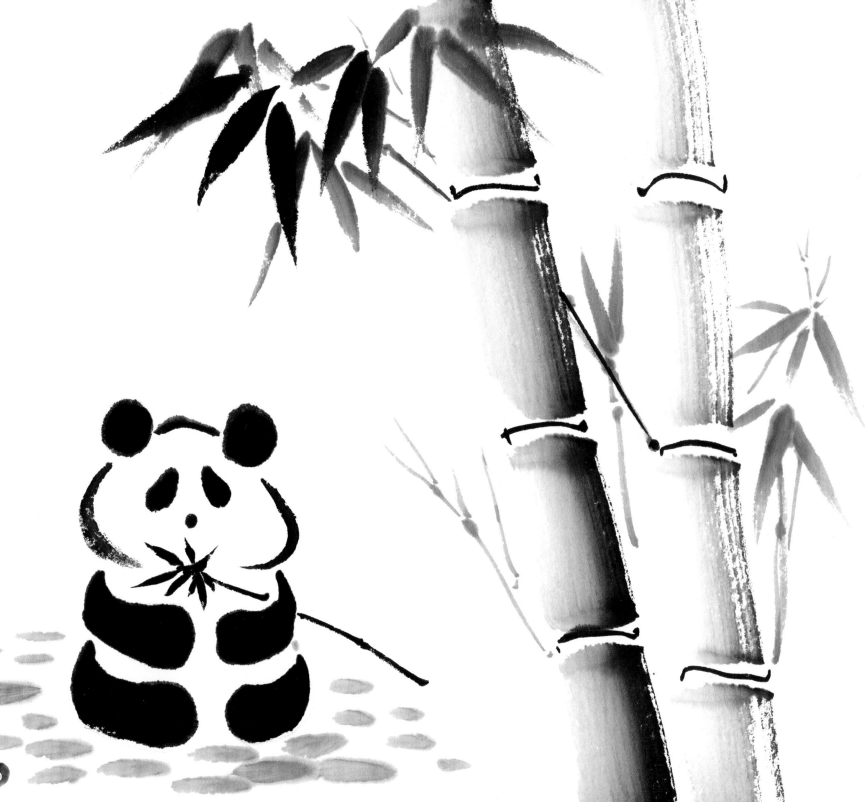

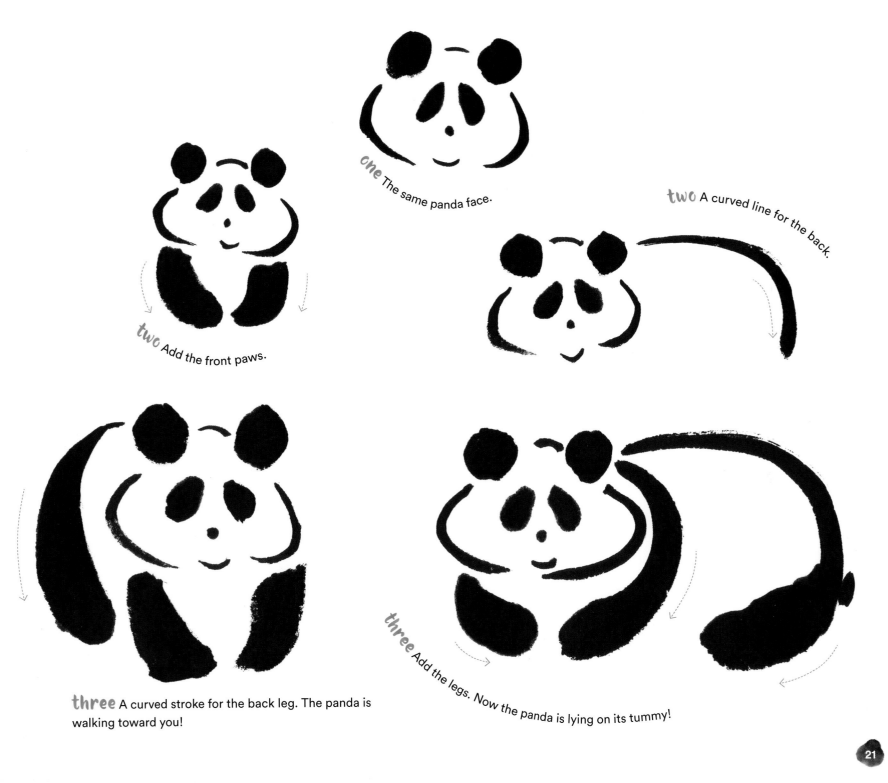

one The same panda face.

two A curved line for the back.

two Add the front paws.

three A curved stroke for the back leg. The panda is walking toward you!

three Add the legs. Now the panda is lying on its tummy!

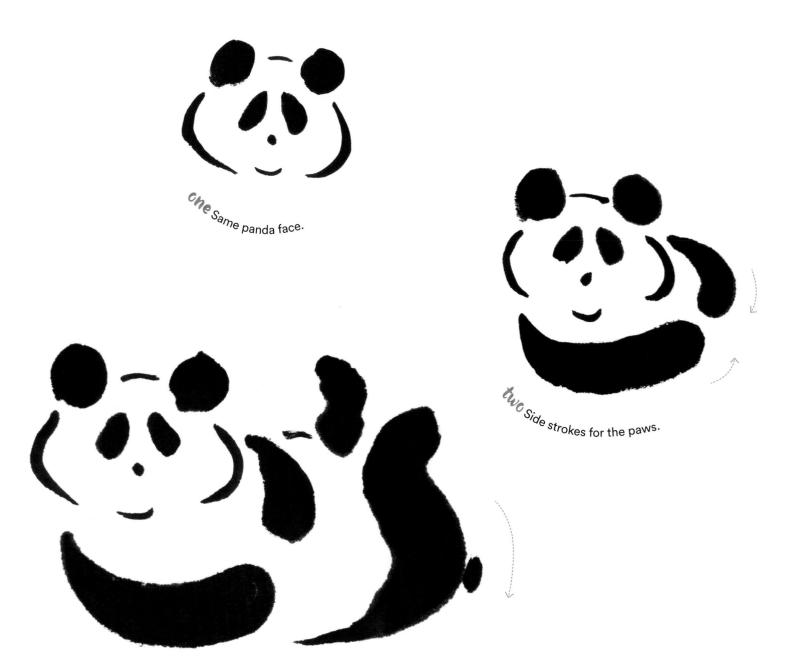

one Same panda face.

two Side strokes for the paws.

three Paint the back legs sticking up in the air.

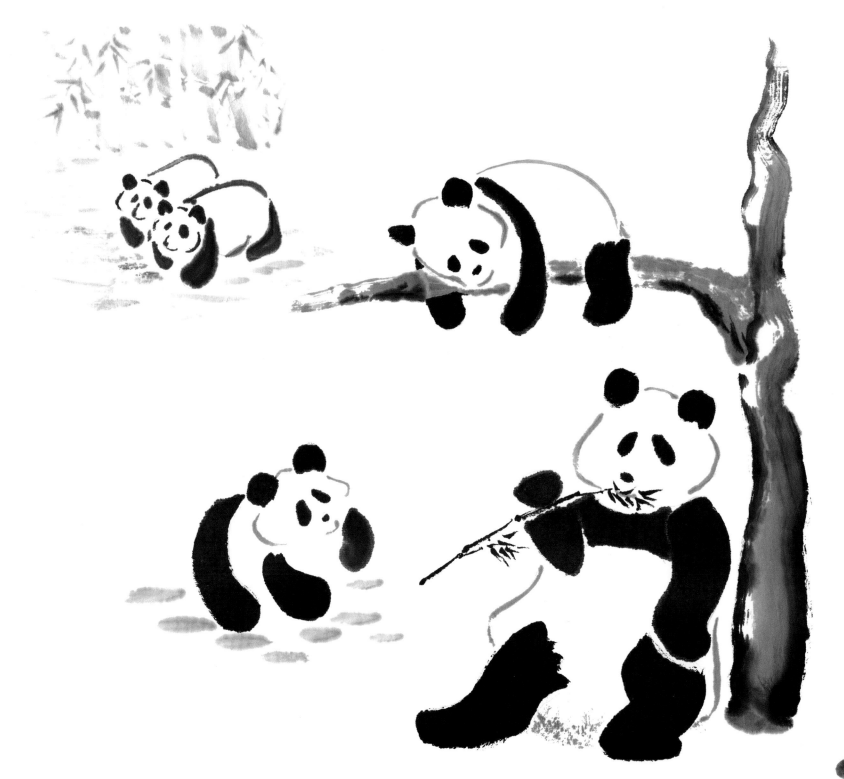

The Fire Breathers

"S" strokes and press strokes—
your dragon is flying freestyle!

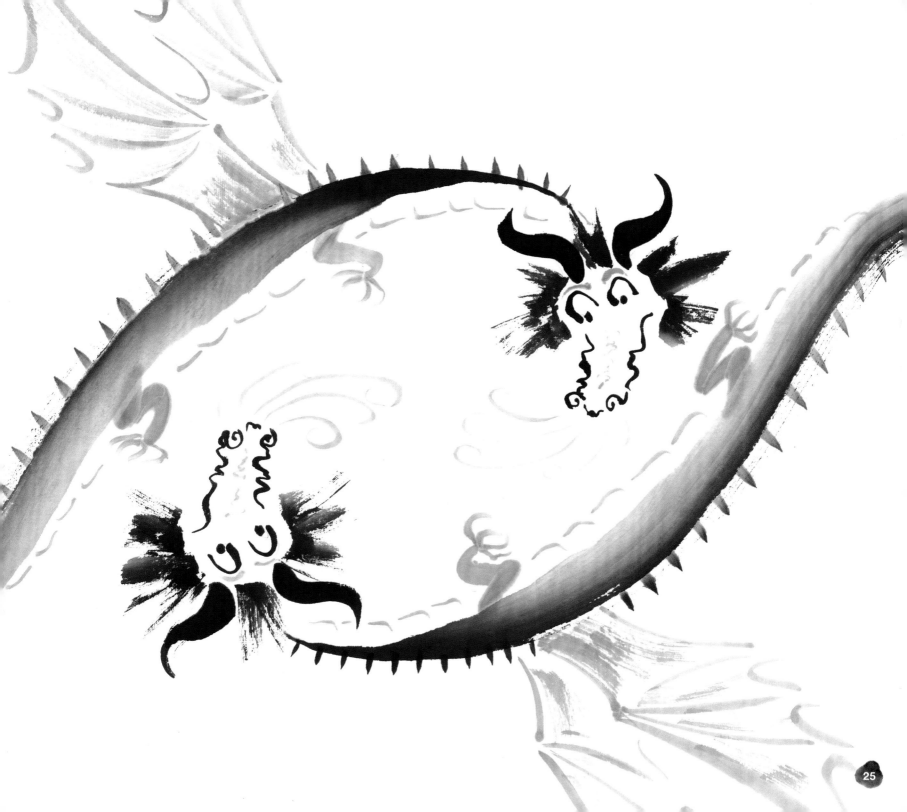

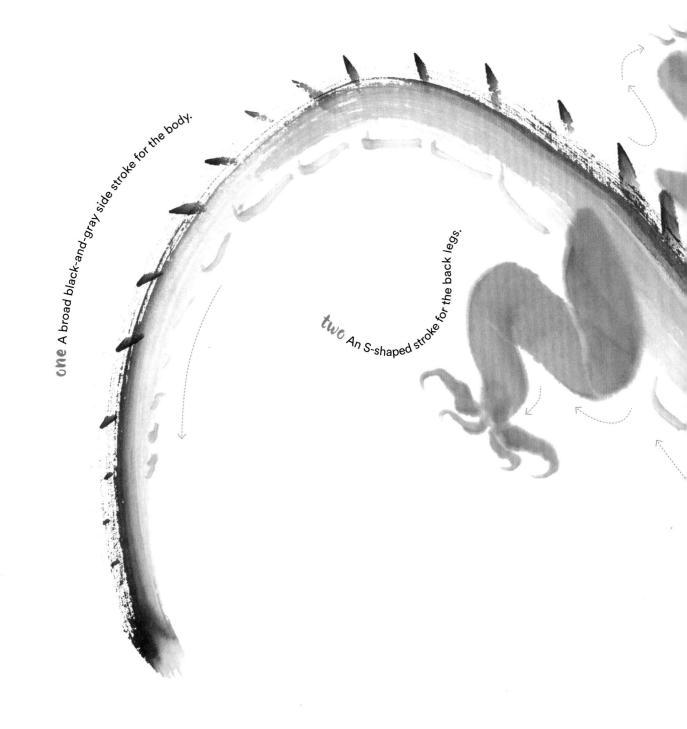

one A broad black-and-gray side stroke for the body.

two An S-shaped stroke for the back legs.

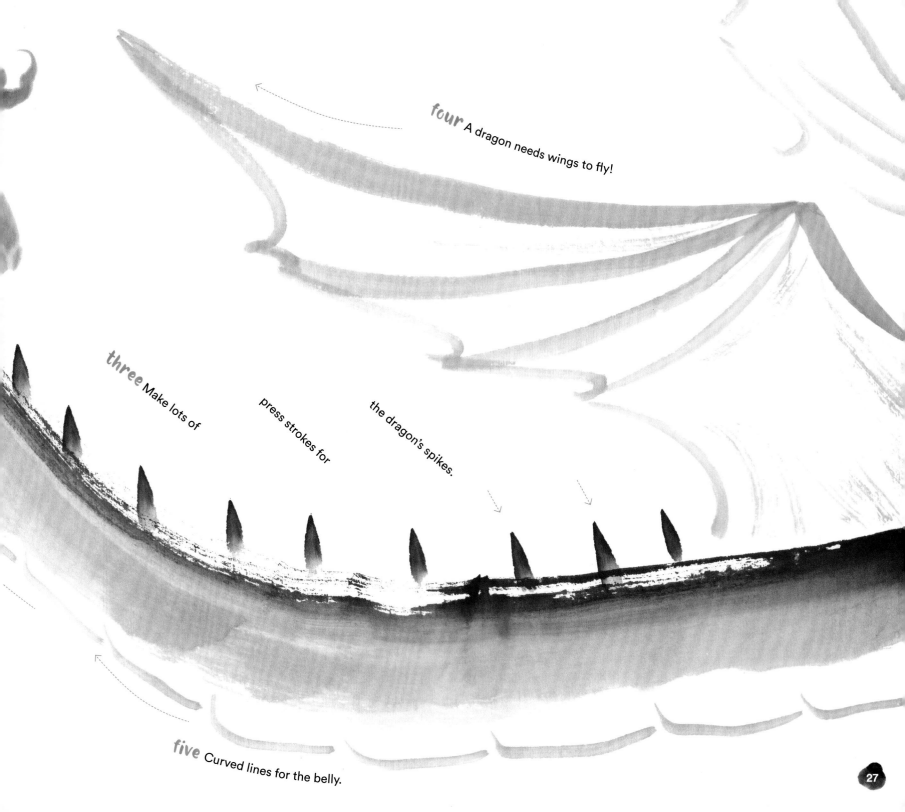

four A dragon needs wings to fly!

three Make lots of press strokes for the dragon's spikes.

five Curved lines for the belly.

27

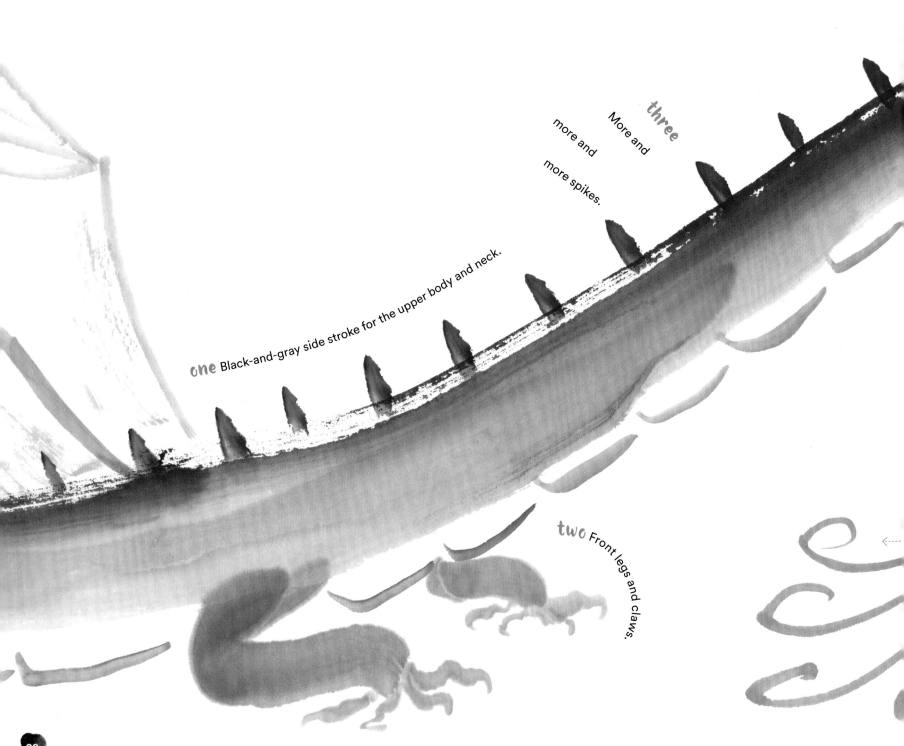

three More and more and more spikes.

one Black-and-gray side stroke for the upper body and neck.

two Front legs and claws.

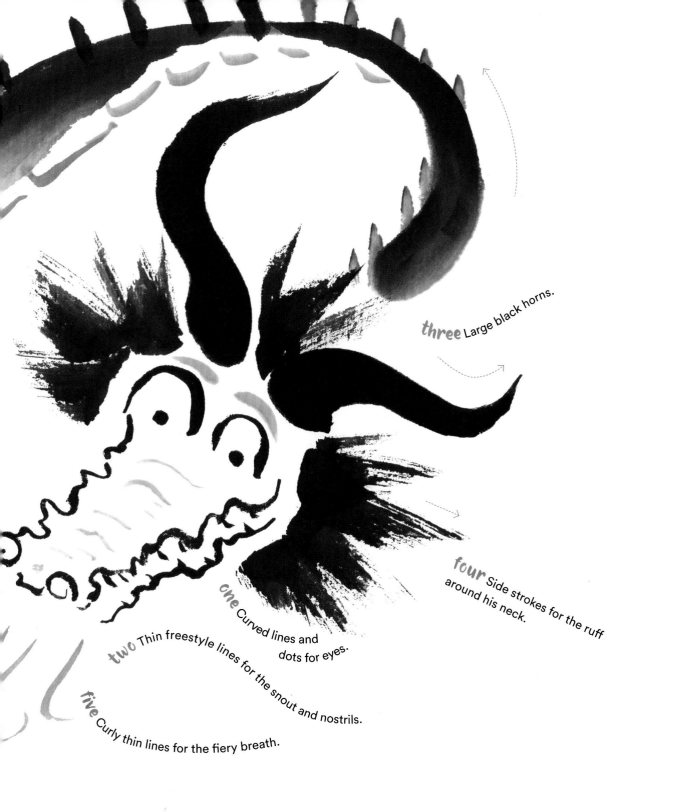

three Large black horns.

four Side strokes for the ruff around his neck.

one Curved lines and dots for eyes.

two Thin freestyle lines for the snout and nostrils.

five Curly thin lines for the fiery breath.

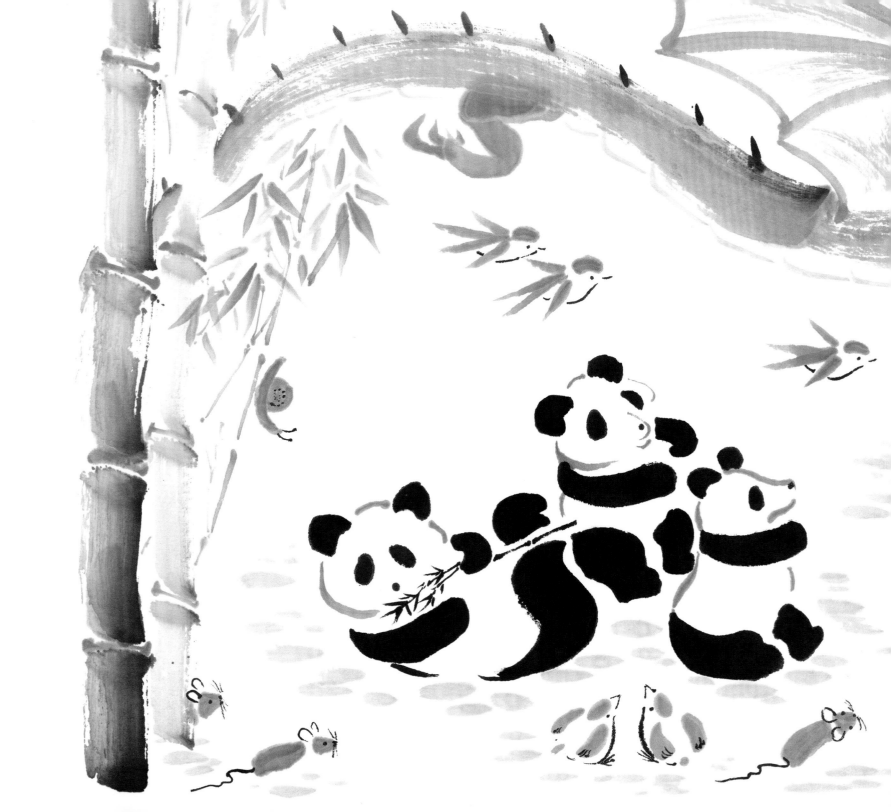

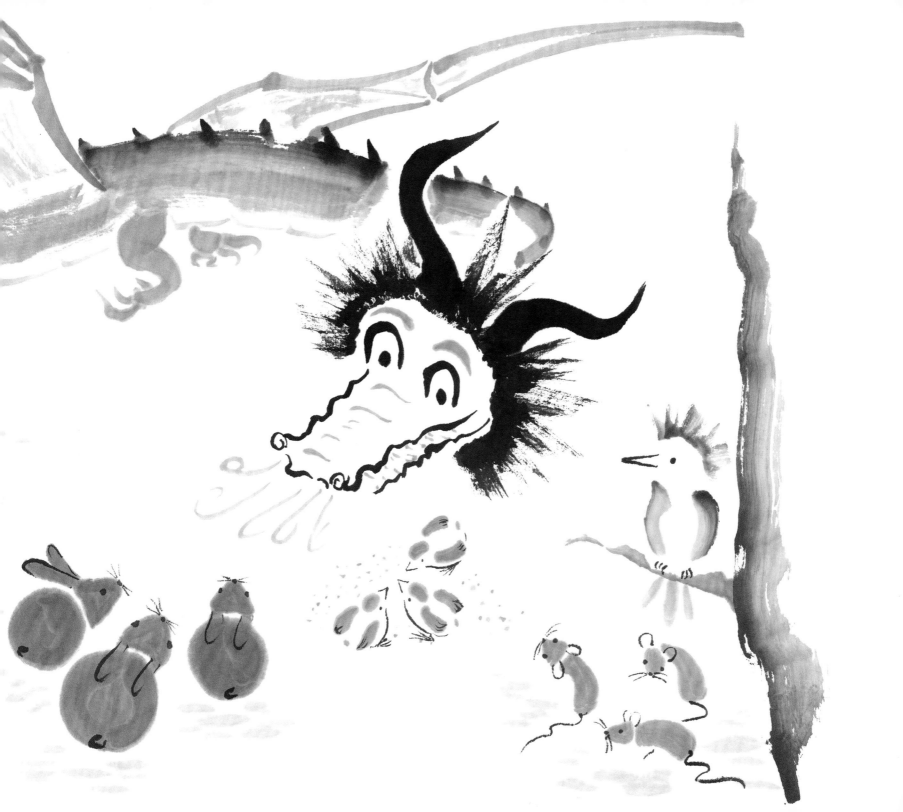

For Parents and Teachers

Here you will find basic instruction in sumi-e and some tips on the tools you will need to make the paintings shown in this book.

SUPPLIES AND SETUP

Cover your work surface with newspaper or a piece of felt, and place your materials near the hand you paint with.

Water container
For rinsing the brush and diluting the black ink/paint when necessary.

Ink
Bottled sumi ink or black tempera paint. Tempera paint is thicker than ink so you will need to thin it a little with water.

Small dishes
One for black ink/paint and one for gray (black ink/paint diluted with water).

Smooshing plate
Plate or plastic lid for patting the brush to work the ink from the tip up into the body of the brush.

Black fine-tip marker pen
Optional.

Paper
Plain newsprint is fine to start with. You can try various kinds of rice paper later.

Soft folded rag or paper towels
For blotting the brush.

Brushes
Start with a medium-size sumi brush. You can add small and large brushes later. If you can't find a sumi brush, you can use any soft brush that comes to a nice point.

Sumi suppliers: Daniel Smith Artists' Materials, Blick Art Materials, Oriental Art Supply, and Awesome Art Supply. More resources at YvonnePalka.com.

CARE OF THE BRUSH

1 Before painting: Brand-new brushes from China or Japan are stiffened with glue. Soak the brush in cool water for a few minutes to soften the bristles. Then rinse thoroughly in clean water.

2 Cleanup: When you finish painting, rinse the brush in clean, cool water (never use soap), pat or squeeze it gently in a towel to get the excess water out, and lay it so the brush extends over the edge of a table. This allows all sides of the brush to dry evenly. Don't leave the brush in water or dry it upside down—the water from the tip will run into the handle and dissolve the glue that holds the brush together.

HOW TO HOLD THE BRUSH

1 Hold the brush vertically about a third of the way up the handle (not at the tip, the way you hold a pencil) with your second and third fingers on one side and your thumb on the other side. When the brush is perpendicular to the paper you have good control over it and can paint a variety of strokes.

2 You want your arm to be able to move freely so the brush can dance across the paper with energy!

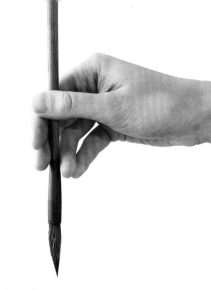

LOADING THE BRUSH
Black Ink (One Color)

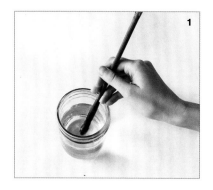 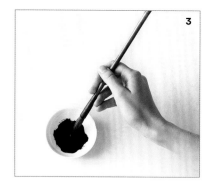 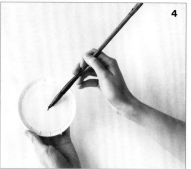

Give the brush a good drink so that it is wet all the way through. Then wipe the brush on the edge of the jar to remove some of the water.	Blot the base of the brush on the paper towels to remove more excess water if needed.	Dip the brush in black ink about halfway. Wipe on the edge of the dish to remove excess ink and shape the brush to a point.	Pat and stroke the brush on the smooshing plate to work ink up into the body of the brush and to keep the point.

Gray and Black Ink (Two Colors)

1 First repeat steps 1–4 above using gray ink. Blot the base of the brush to remove excess ink or water if needed. Your brush is now loaded with gray ink.

2 Dip the tip in black ink, wipe on the edge of the dish, and pat or smoosh lightly so the black on the tip blends with the gray in the middle of the brush. Stroke the brush on the smooshing plate to keep a point. Your brush is now loaded with two colors—gray and black.

3 Use this for press strokes, side strokes, and wherever you want shading in your stroke.

PRACTICE STROKES

Hold the brush vertically to make these strokes.

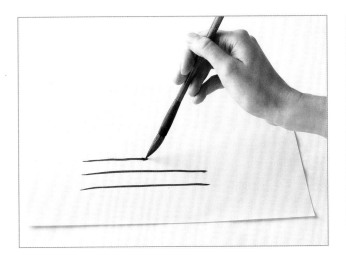

Thin Line

Use the tip of the brush, with light pressure.

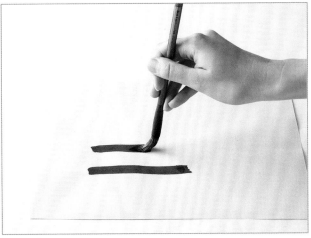

Thick Line

Press a little harder.

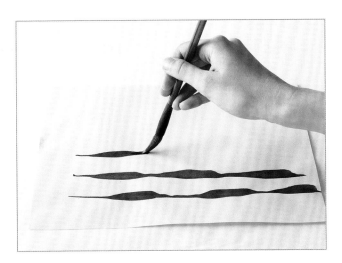

Thick-Thin Line

Change the pressure.

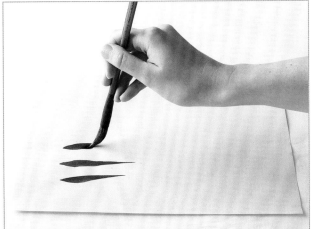

Bamboo Leaf

This is part of the thick-thin line stroke. First press down to make the thicker base of the leaf, then lighten up the pressure as you paint the stroke, like an airplane taking off.

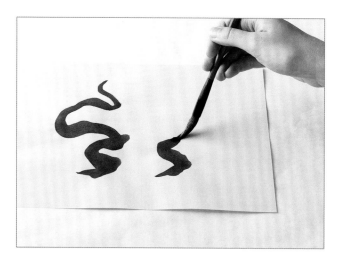

Freestyle Line
Paint a free line going any way you like—thick and thin, twirling around. Is it a tree branch or a dragon's body? It's whatever you think it might be!

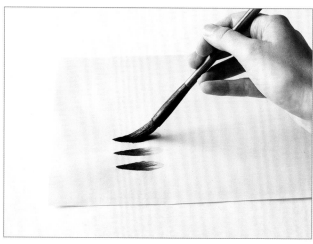

Press Stroke
Load the brush with gray and black ink. Lay the brush down flat, and press it into the paper.

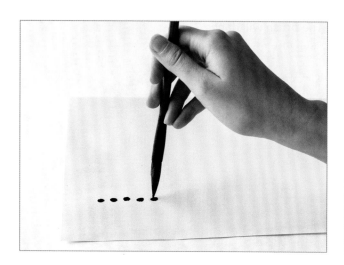

Dots
Touch the tip of the brush to the paper.

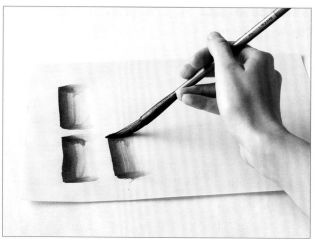

Side Stroke
Load the brush with gray and black ink. Lay the brush on its side and make a broad stroke moving from the bottom to the top of the paper.

More about Sumi-e

THE BRUSH DANCES AND THE INK SINGS

"The brush dances and the ink sings" is the perfect description of a sumi painting. The artist is working to capture the essence or spirit, known as *qi* (pronounced chi), of her subject in the painting. When the painter is very familiar with her subject (for example, her pet rabbit), her awareness of its essence will allow her to paint it very freely and simply. The brush will dance, the strokes will be lively and free, and the image will seem alive on the paper. Others will be drawn to looking at her rabbit painting because it is full of qi. A good sumi painter can make even rocks come alive!

Similar styles of painting with brush and ink are familiar in other Asian countries, particularly China and Korea, so sumi-e is now often referred to as Asian brush painting.

SUMI PAINTINGS ARE ALIVE

There are many folk stories that tell us about how thoroughly alive sumi paintings can be. One is about Sesshu, a Japanese master painter from the fifteenth century. As a boy, he displeased a Zen priest by painting cats instead of fulfilling his temple duties. As punishment, he was sent away and found himself sleeping in an old abandoned temple. To create company before he went to sleep, he painted cats on every wall and screen he could find. In the morning, after a night of horrible screams and noises, he crept out of his hiding place only to see a monstrous goblin rat lying dead on the floor. All the cats he had drawn now had blood on their mouths! They had come alive and killed the goblin rat!

THE EARLY DAYS OF SUMI-E

Ink painting began in China during the Han dynasty (206 BC–AD 220) in the form of calligraphy, which means "beautiful writing." The brush strokes used to form Chinese characters are the basis of the brush strokes used in painting. Chinese characters are often pictorial representations of the meaning of the word, so it was a natural transition from writing characters to painting pictures. Japanese Zen-Buddhist monks traveling in China during the Sui and Tang dynasties (AD 581–907) encountered this style of painting and brought it back to Japan where it developed and flourished, both in painting and calligraphy.

POETRY WITH SUMI-E

Many Asian brush paintings are seen with calligraphy, often in the form of a poem that says something about the painting. Traditionally an artist was often a poet as well. One ancient and well-known kind of poetry is haiku, a Japanese three-line form that consists of five, seven, and five syllables. Haiku, like sumi painting, seeks to capture the essence of an experience, such as a moment in nature. For example, a haiku that might appear with a panda painting in this book could be:

Bamboo leaves quiver
Pandas playing roll about
Panda-monium!

THE FOUR TREASURES

As you now know, sumi-e gets its name from the ink used for painting. Traditionally the ink comes in the form of a flat and often beautifully decorated black ink stick (sumi) made from densely packed pine or carbon soot mixed with glue. To make ink for painting, you carefully grind the stick with a little water on a special inkstone called a *suzuri* until you get a smooth black ink of desired strength. These days it is also possible to buy prepared ink (see page 33).

The materials of sumi-e are traditionally called the Four Treasures. That's because they are the treasures that help you create paintings that are full of energy and life, and capture the essence of the subject. Besides the ink and inkstone, the two other treasures are the brush and paper.

Brushes often have bamboo handles and are made from the hair of different kinds of animals: soft ones from sheep or rabbit hair and stiff ones from horse, badger, deer, or weasel fur. A sumi painter will use a variety of brushes of different sizes and textures to make a painting. The paper is often called rice paper but it is actually made from a variety of plant materials such as mulberry or bamboo.

SEALS OR CHOPS

On most paintings, you will find one or more red seals, or "chops." One of the seals is usually the signature of the artist, either their name in Chinese characters or a word that they feel represents their feeling at that moment, such as serenity or happiness. Other chops might express qualities or images meaningful to the artist, perhaps the animal of their birth year in the Chinese zodiac such as the tiger or the dragon. You can make your own seal or chop, or use a rubber stamp.

BOOKS ABOUT SUMI-E

You can learn more about sumi-e. There are many more books available.

The Sumi-e Book by Yolanda Mayhall
The Boy Who Drew Cats by Margaret Hodges
A Young Painter by Zheng Zhensun and Alice Low
The Sons of the Dragon King by Ed Young
Dragon Fire: Ocean Mist by Yvonne Palka

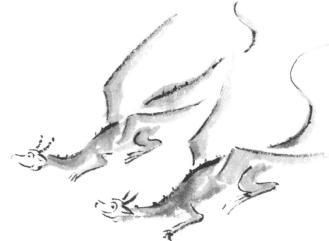

About the Author

YVONNE PALKA is an award-winning sumi painter, an author, a lover of the natural world, a retired college professor, and a grandmother. Her first sumi illustrated book, *Dragon Fire: Ocean Mist*, an adventure story set on the Pacific Northwest coast, won a Moonbeam Children's Book Award. Yvonne loves sumi painting for the simple elegance with which it captures the spirit of nature. Inspired by this simplicity, she teaches children and adults the essence of sumi painting in schools and other community settings. Since it was first published, *Super Simple Sumi-e* has won two gold medals and one silver medal for creative literature for children.

Yvonne currently lives in Minneapolis, Minnesota. You can find out more about her on her website, YvonnePalka.com.